VAN GOGH'S FLOWERS
— AND LANDSCAPES —

Celebrated Subjects of the Great Artists

❧ JANICE ANDERSON ❧

THEMES AND REFLECTIONS

Van Gogh's Flowers

—— and Landscapes ——

Celebrated Subjects of the Great Artists

 Janice Anderson

SMITHMARK

This edition published in 1997 by SMITHMARK Publishers,
a division of U.S. Media Holdings Inc.
16 East 32nd Street, New York, NY 10016.

SMITHMARK books are available for bulk purchase for sales promotion and premium use.
For details write or call the manager of special sales, SMITHMARK Publishers,
16 East 32nd Street, New York, NY 10016; (212) 532-6600.

Produced by Kingfisher Design, London
for
Parragon
Unit 13–17
Avonbridge Trading Estate
Atlantic Road
Avonmouth
Bristol BS11 9QD

ISBN: 0-7651-9764-2

Printed in Italy

10 9 8 7 6 5 4 3 2 1

Acknowledgements
Series Art Director: Pedro Prá-Lopez, Kingfisher Design, London
Designers: Frank Landamore, Frances Prá-Lopez, Kingfisher Design, London
Editor: Anne Crane

The publishers would like to thank Joanna Hartley at the
Bridgeman Art Library, London for her invaluable help

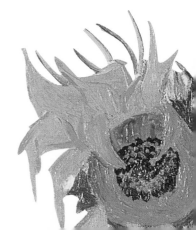

VINCENT'S VISION

NATURE'S MOODS CAUGHT IN PAINT

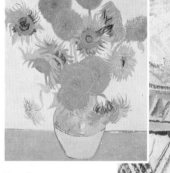

Sunflowers
1888, Oil on canvas

FROM QUITE EARLY ON in his childhood, Vincent van Gogh tended to be a solitary person. He was made so as much by his own intense, introspective nature as by what his family, especially his father, saw as his 'awkward' personality. It was perhaps this solitariness, allied to his upbringing in a religious household, which made him very aware of nature and very sensitive to its changing colours and atmosphere. 'One can never study nature too much or too hard', he wrote in one of his letters.

Vincent van Gogh's artistic career was short, just ten years from start to finish, and the masterpieces which ensure him a place among the greatest Western artists of all time were produced in bursts of almost frenetic activity in a two-and-a-half-year period in Provence in the south of France and at Auvers-sur-Oise, north of Paris. The brilliant, clear light of the Midi which emphasized and enhanced the colours of everything upon which it fell inspired van Gogh.

Canvas after canvas was filled with vivid images of flowers, from the delicate fruit and nut tree blossoms and the scarlet poppies of spring to the rich violet irises, glorious golden sunflowers, opulent oleanders and damask pink roses of summer. While he was intensely aware of the details of nature — a beetle on a half-opened rose, a death's-head moth on an arum lily, butterflies among the summer grasses, red bindweed flowers twining themselves round stalks of wheat — van Gogh also gloried in nature's wide horizons. He painted many landscapes in which great, cloud-filled skies merged with horizons marked by the edges of fields and the shapes of trees; there were others in which fiery gold

Vincent van Gogh,
*Self-portrait with
Shaven Head,*
1888, Oil on canvas

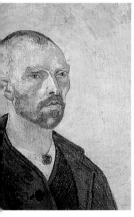

suns or delicate crescents moons and brilliant stars dominated a dark Earth punctuated by the twisted black shapes of cypress trees.

It was a natural world in which man was central. Van Gogh's finest, most deeply felt paintings were done in gardens created by man or in a countryside given shape by the needs of agriculture. It was no co-incidence that subjects which recurred again and again in his work, including peasants working in fields or in vineyards, men sowing seeds in sun-drenched fields, rows of fruit trees in blossom, all had their origins in man's relations with the land and with nature.

They also had their origins in van Gogh's earliest years, for he was born in a farming district and early came to understand the calm and peace of a country in which man drew his living from his relationship with nature. As a boy and young man, van Gogh felt so concerned with the lives of country peasants and poor industrial workers that he tried to become a missionary-teacher among them. Later, the focus of his interest changed and van Gogh, the artist, came to be more in sympathy with the view of realist artists like Corot and Daubigny that true civilization meant life lived in harmony with nature.

Vincent Willem van Gogh was born in Groot-Zundert, in the southern Dutch province of Brabant, on 30 March 1853. His brother, Theo, who was to be his closest friend and confidant and greatest supporter, was born three years later. They and their other brother and three sisters were the children of Theodorus van Gogh, a pastor of the Dutch Reformed Church, and his wife, Anna Carbentus, daughter of the royal bookbinder in The Hague. Theodorus van Gogh came from a large family and had three brothers working in the art business. When the time came for the teenage Vincent to find work, it was his Uncle Cent (short for Vincent) who found the boy a job in The Hague branch of the art dealers, Goupil and Co., where he served a four year apprenticeship before being sent to the company's London office in 1873.

Vincent van Gogh enjoyed his first months in London immensely, delighting in the great city's many beautiful parks and the gardens full of flowers. He walked miles through London in all seasons and all weathers, noting and taking pleasure in the seasonal changes. Despite the enormous amount of reading he was doing at this time - the poetry of Shakespeare and of John Keats and the English Romantics, the novels of George Eliot and Charles Dickens were all read and appreciated by the intense young man in his boarding house in Clapham - it was with an eye trained by the work of the great Dutch artists of the past and by the artists he was discovering in London's galleries that he looked at the world.

By the time van Gogh returned to Holland for his first holiday, there had been a change. Made unhappy by a love affair gone disastrously awry, Vincent seemed quiet and dejected — but he was drawing a great deal. This was something new to his family, and had been inspired by his admiration for the work of the artists who provided the illustrations for magazines like The Graphic and The Illustrated London News. Apparently, he had taken up drawing in London, stopping on his walk home from work in the evenings to draw things he saw along the Thames Embankment.

After two years in London, Vincent was transferred to Goupil and Co.'s Paris office. By now, however, he was quite out of sympathy with the business of picture dealing and soon handed in his notice. The next ten years in van Gogh's life were to be ones of great emotional turmoil while he sought his way in life. He was a bookshop assistant for a time, failed to pass the exams which would have allowed him to study Theology at Amsterdam University, and became a bible teacher and preacher first, briefly, in London and then among miners in the Borinage, an impoverished area of Belgium. It was during this increasingly unhappy period that van Gogh took up drawing seriously, making many copies of the work of artists like Millet.

In 1879 he was dismissed by his mission's director because of his eccentric behaviour: he had given away most of his clothes and food and all his money so that he could feel at one with the poor people he was trying to help. Eventually, in 1880, he was for a short time a student of anatomy and perspective in Brussels.

The one clear thing in all this was that by now Vincent van Gogh had discovered his purpose in life, which was to be an artist. Despite his lack of formal tutoring, Vincent van Gogh for the next five years doggedly pursued the business of learning to draw and to paint.

He worked at his family homes in Etten and at Nuenen, where his father had a new living, producing hundreds of drawings and paintings of peasant life. At this time, his work was characterized by the dark colours he used and the heavy forms he drew. In The Hague, his cousin by marriage, the artist Anton Mauve gave him some tuition in oil painting. He spent some time in the remote province of Drenthe, then went to Antwerp in 1885, where he first encountered Japanese prints and took a great interest in Rubens' art. He lasted a month at the Antwerp Academy before disagreeing with his teachers and leaving precipitately.

In February 1886, Vincent van Gogh arrived in Paris, where his brother Theo was working as a picture dealer, a business in which he was far more successful than Vincent had been. For Vincent van Gogh, this was the turning point in his life.

For a time Vincent attended the Atelier Cormon, where he met Henri de Toulouse-Lautrec and Emile Bernard. In time, he met most of the leading artists of the day, including the great Impressionists, from whose work he learned a great deal. Paul Gauguin and Paul Signac both became close friends, and there were several painting sessions in Asnières for van Gogh and Signac.

Van Gogh's paintings done at Asnières used the lighter palette of the Impressionists and his subjects were Impressionistic: pictures of restaurants and

one restaurant interior in which all the tables were decked with wonderfully exuberant vases of flowers. In their use of short strokes and dots of pure colour, his paintings also showed an experimenting with Seurat's divisionism (also called pointillism) theory, which Signac was much involved with at this time.

By early 1887 van Gogh felt himself to be so much in the artistic swim in Paris that he arranged two exhibitions at the well-known Café Tambourin, one of Japanese prints, of which he was by now a fervent admirer, and one of paintings by himself, Emile Bernard, Toulouse-Lautrec and a fellow student at the Cormon studio, Anquetin.

Catalogues of Vincent van Gogh's work during his Paris time list about 200 oil paintings and many drawings. They show a great change in emphasis from what he had been doing pre-Paris. There are no peasants and workers in dark-toned country landscapes, no still lifes of humble domestic objects. The emphasis is not on subject matter so much as on the techniques of the artist: composition, colour and brushwork.

Searching for a personal style through the use of these techniques, van Gogh painted in the two years he was in Paris nearly fifty flowerpieces, thirty-five still lifes, a series of self-portraits and some fifty paintings done en plein air — that is, landscapes, but landscapes with a much lighter palette and a more free and assured touch than anything he had done at Etten or Nuenen.

After two years in Paris, van Gogh had found his personal style. It was to come into glorious fruition under the warm sun of the Midi. Vincent van Gogh went to Arles in February 1888, in search of a warm, sun-filled climate and a countryside akin to what he imagined Japan to be like. He also hoped to set up a studio, indeed, a colony, of like-minded artists in the south of France.

At first, all went well. The light, the colours and the countryside, at its most beautiful in spring and early summer, inspired him to great activity. In just over

a year in Arles he painted nearly 200 oils and did over 100 watercolours and drawings. There were many landscapes, but also still lifes, portraits and flowerpieces. Subject matter had become important again: as van Gogh wrote in one of the hundreds of letters he sent to Theo and other friends from Arles, 'all reality is symbolic'. Thus, in his paintings every object, every shape had a meaning for him.

Van Gogh leased a small, yellow-painted house in Arles. Here he would have his studio of the south. But with the arrival in October 1888 of Paul Gauguin, the first artist whom van Gogh saw as sharing his artistic paradise, everything began to go wrong. The tension between the two quite incompatible men was palpable from the start and reached a crisis just before Christmas when van Gogh, in a state of feverish excitement caused partly by the news that Theo was planning to marry, cut off a piece of his ear and took it to a woman in a brothel in Arles. Gauguin came home to the Yellow House to find a heavily blood-stained van Gogh lying on his bed. Van Gogh was taken to the hospital in Arles, where he seemed to recover quite quickly, especially after Theo arrived.

From now on until his death in July 1890, Vincent van Gogh was never free of the fear that a mental crisis could descend on him at any time, and that he would be unable to do anything to prevent them. There were four mental breakdowns in quick succession early in 1889, during which van Gogh was unable to work, though he made copies of existing paintings. He was well enough to take Paul Signac to the Yellow House in March to look at the work he had been doing, but there was another crisis in April and in May van Gogh made himself a voluntary patient at a mental asylum in Saint-Rémy-de-Provence.

Van Gogh was to stay at the asylum in Saint-Rémy for just over a year. He quickly noticed how different the landscape was here from what he had been painting around Arles. The countryside, dominated by the jagged outlines of the

Alpilles, was harsher, drier. There were groves of olive trees, clumps of tall, exotic, black cypress trees. Even the garden round the asylum was wilder and more unkempt than the gardens he had been painting in Arles.

Saint-Rémy offered van Gogh new subjects, new motifs. Despite his frequent mental crises, he was able to work: over one hundred new oil canvases, many painted with a new, subtle range of colours, plus forty copies of existing works and a hundred drawings flowed from him in this last full year of his life.

In January 1890, Theo's wife, Jo, gave birth to their son, whom they christened Vincent Willem. The baby's uncle painted a glorious study of almond blossom against a blue sky, symbolizing the new life in the family — and the next day was felled by a mental crisis so severe he could not work at all for several weeks. Once recovered, he began thinking longingly of his family and the North again. Realising that he could never be sure of being completely well again, he began making plans to return home, or, at least, to somewhere near home.

It was Camille Pissarro who suggested that Vincent should move to Auvers-sur-Oise, a village twenty miles north of Paris well known to the Impressionists, several of whom had painted there. The presence in Auvers of Dr Paul Gachet, a doctor and art collector very sympathetic to the work of the Impressionists, would be a plus, as far as Vincent van Gogh was concerned.

Van Gogh left Saint-Rémy-De-Provence in May 1890, spent a few days in Paris with Theo, then went to Auvers-sur-Oise, where he arrived on 20 May. Apart from a short break in Paris with Theo at the beginning of July, van Gogh spent the last months of his life in Auvers.

Once again, his painting was frenetic: seventy oil paintings and thirty watercolours and drawings in less than fifteen weeks. As in the south of France, the fertile fields of the countryside inspired him to some of his most intensely felt

landscapes, while Doctor Gachet's garden and the garden of the house in which the painter Charles Daubigny had lived were the sources of several delightfully sunny garden and flower studies. The vivid colouring, thickly applied, and the writhing forms which characterized many of the paintings in Saint-Remy and Auvers and which were so expressive of his tormented, even tortured emotions at this period were to have a considerable influence on the work of German Expressionist artists in the first decades of the twentieth century.

It was in one of the fields where he had been painting so intensely in recent days that Vincent van Gogh, deeply depressed by money worries and fearful for his future, shot himself in the chest on 27 July 1890. He managed to get himself back to the café where he had a room in Auvers, Theo was called from Paris, and Vincent died in his arms on 29 July. Theo was to die just six months later and the brothers are buried side by side in the cemetery by the church at Auvers-sur-Oise.

IN THE ORCHARD

1883 Pen transferred to lithograph with pen and ink

Vincent van Gogh first began drawing in a serious way during the years he was in England, first in 1873-5, then again in 1876. He greatly admired the black and white drawings of the artists published in such magazines as The Graphic and The Illustrated London News and for some years it was his ambition to become a magazine illustrator. His work in London was untutored, something which he was still regretting years later when he was doing work like this drawing of a man working in an orchard in Holland.

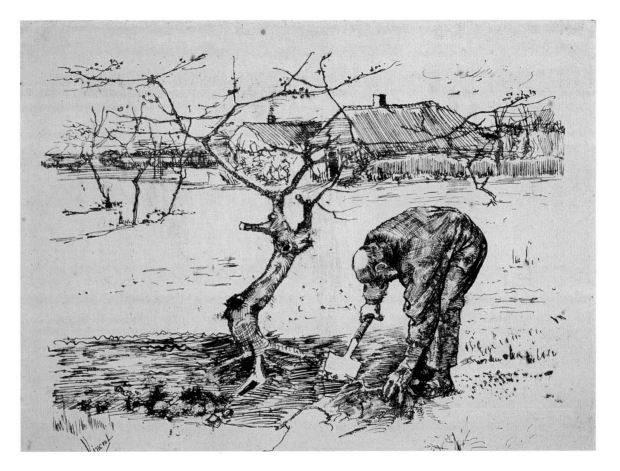

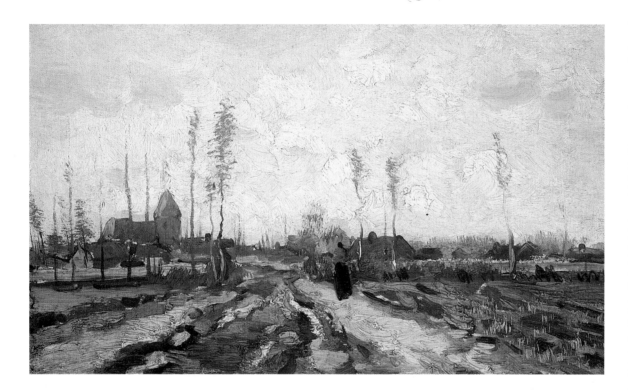

LANDSCAPE WITH A CHURCH AND HOUSES, NUENEN

1885 Oil

Van Gogh's father, a Protestant minister, moved with his family to a new living at Nuenen in North Brabant in 1883. Vincent joined his family there at the end of the year. Between December 1883 and November 1885, when he left Nuenen for Antwerp, van Gogh produced nearly 200 paintings and over 200 drawings, most of them concerning the life of the peasants of Brabant and the countryside they lived in. At first, his great concern was to be 'an illustrator of the people', but by 1885 artistic considerations were becoming of greater importance to him than recording the life of the peasants of Brabant.

THE PARSONAGE GARDEN AT NUENEN IN WINTER

1885 Oil on canvas

Van Gogh painted and drew the garden which surrounded his father's parsonage at Nuenen at all seasons and in all weathers. Here, he records it on a bleak day in January, a pale sun giving some light to the scene. As far back as 1873, when he first arrived in London, one of the things which had attracted him to Clapham, where he found lodgings, was the tradition for every house to have its own neatly kept garden in front, well stocked with flowers and trees, while London's many beautiful parks, with their wealth of flowers, were a constant joy to him. Such things were to remain important to Vincent van Gogh all his life.

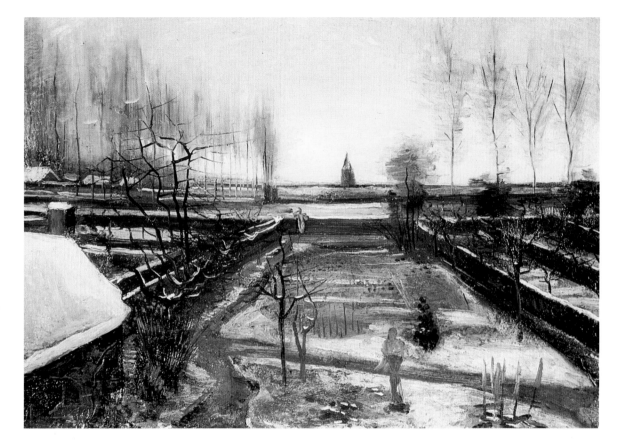

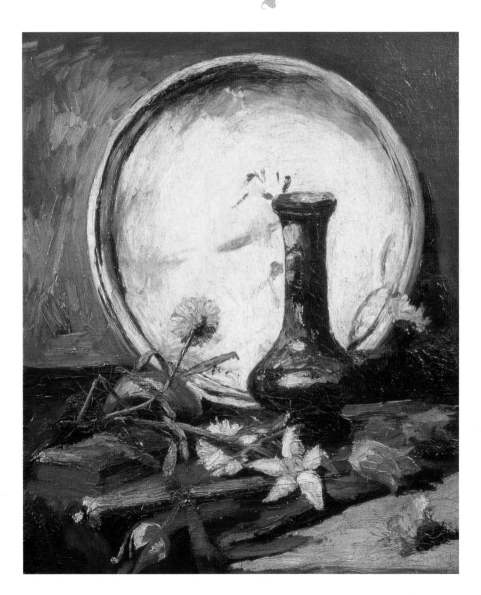

STILL LIFE WITH FLOWERS

c.1886 Oil on canvas

Vincent van Gogh's two years in Paris, from February 1886 to February 1888, became a time of continuing experiment. No longer concerned just about the subject matter of his painting, he concentrated on the abstract qualities of art: brushwork, composition and colour. All the nearly 50 flowerpieces he produced in Paris were experiments in these three aspects of painting. This dark-toned canvas combines his earlier interest in still life with his new concentration on colour and was done during his great bout of flower painting in the spring and summer of 1886. As he explained to an English friend, he was getting accustomed to using a scale of colours other than grey, a colour still prominent in this painting.

LE MOULIN DE BLUTE-FIN

1886 Oil on canvas

Montmartre, where Vincent and Theo van Gogh moved to in the summer of 1886, was still quite rural in appearance, despite being so close to the centre of Paris, and its skyline was dominated with three splendid windmills surrounded by vegetable gardens and allotments. Where Pierre Auguste Renoir had chosen to portray Montmartre's most famous windmill, the Moulin de la Galette, as a place of holiday gaiety and jollity, van Gogh chose a more topographical, almost architectural, approach to the subject. Here, he shows the Moulin de Blute-Fin as if it were still a working windmill in a semi-rural landscape, surrounded, not by holidaymakers, but by the signs of cultivation and outdoor work.

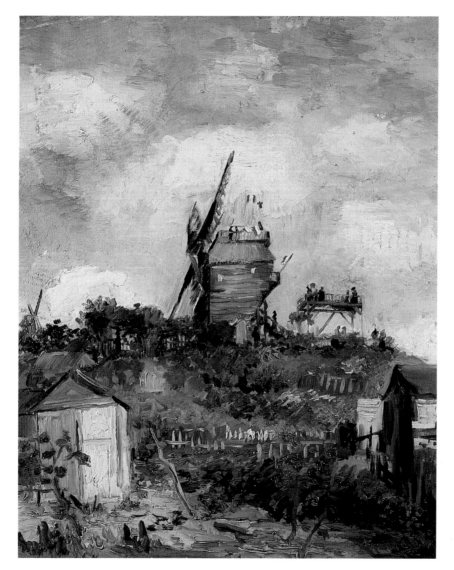

VASE OF HOLLYHOCKS

1886 Oil on canvas

Van Gogh had been in Paris about six months when he painted these hollyhocks, a time during which he had met and made friends with numbers of the younger artists of Paris, many of whom were committed to working in the ways which the Impressionists had been using since the late 1860s. Although this painting shows that van Gogh was still committed to the dark tones which had marked his Nuenen work and to painting realistically the subject in front of him, there is also an indication of a lightening in tone of his palette and of a care to choose colours which will contrast with each other. The overall effect is to give a new intensity of tone to his still lifes and other work.

Detail

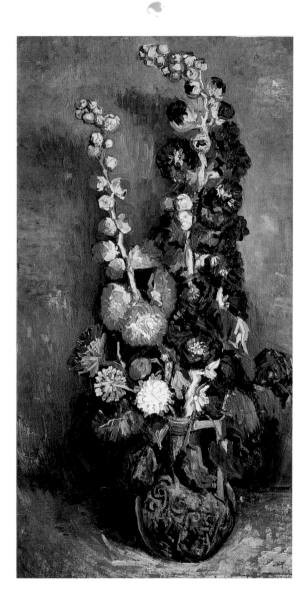

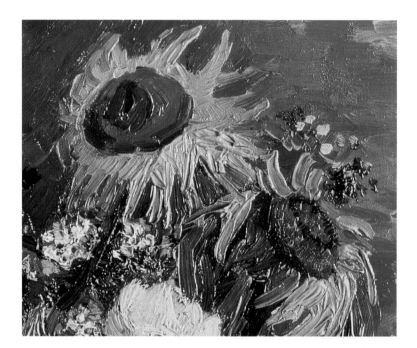

Detail

SUNFLOWERS, ROSES AND OTHER FLOWERS IN A BOWL

1886 Oil on canvas

This close-up of a section of the sunflowers and roses in the painting on page 21 clearly shows the vigorous way in which Vincent van Gogh was painting by the late summer of 1886. The pure colours are laid on quickly in a thick impasto without any careful working out beforehand. Van Gogh achieves balance in the painting by using cool colours for the roses and setting them against the fiery background of the sunflowers. This is the spontaneous painting of an impulsive nature, working quickly and intuitively.

SUNFLOWERS, ROSES AND OTHER FLOWERS IN A BOWL

1886 Oil on canvas

Apart from a few hints of sunflowers in his paintings of the allotments and vegetable gardens of Montmartre, this bowl of flowers represents van Gogh's earliest use of the flower which would later become so closely identified with his art as to be almost a symbol of it. Perhaps Vincent picked the flowers himself on Montmartre, or perhaps friends brought them to him from the countryside: his brother Theo reported to their mother that Vincent was lucky in having many friends in Paris who regularly brought him splendid bunches of flowers to paint.

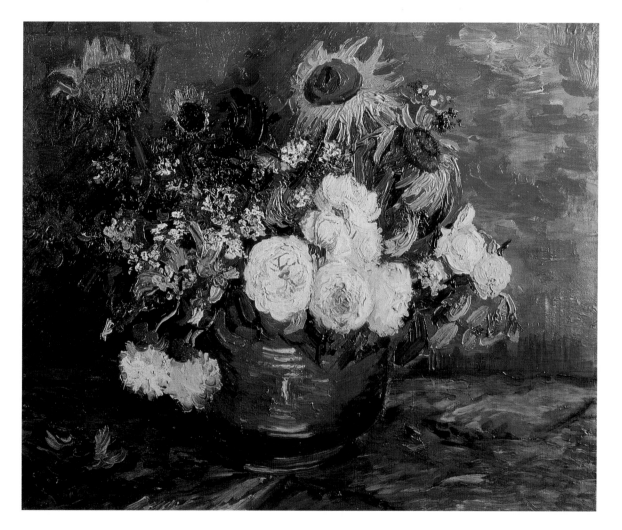

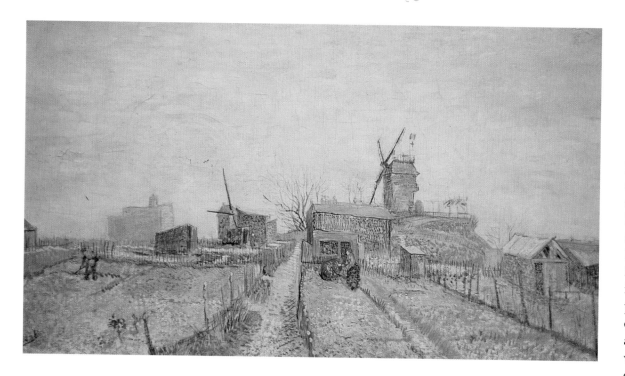

THE ALLOTMENTS AT MONTMARTRE

1887 Oil on canvas

When van Gogh arrived in Paris in February 1886 he soon realised that he had a lot of catching up to do as far as the contemporary art scene was concerned. Foremost among the many artists in Paris were the Impressionists and their followers, preaching the importance of pure colour and painting en plein air. As part of his rapid self-tutoring in artistic thought and practice, van Gogh spent much time out in the open air of Montmartre. This painting of two of Montmartre's windmills and the vegetable gardens surrounding them was painted early in 1887, before the carefully tended plots had burst into full life.

THE PONT DE CLICHY

1887 Oil on canvas

In this picture van Gogh gives us as delightful a view of Paris in spring as any of the Impressionists; indeed, several art commentators have pointed to the similarity between this picture and works like Claude Monet's paintings of boats at Argenteuil or his picture of fishermen on the Seine near Poissy. The stretch of water in van Gogh's painting is also the Seine, near one of the many bridges which cross it in Paris. He has chosen wonderfully light shades of blue and green for most of it, using unexpected touches of red and pink to give it extra life and movement.

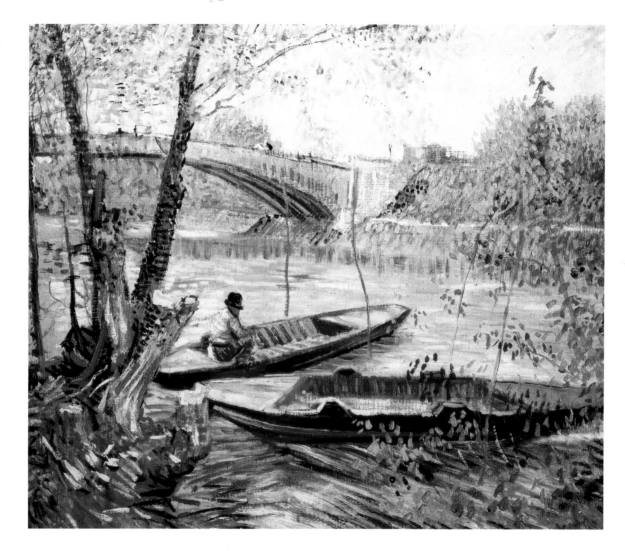

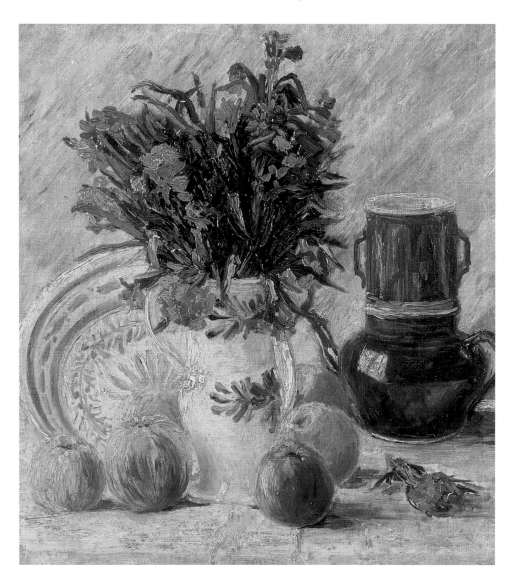

VASE OF FLOWERS WITH A COFFEE POT AND FRUIT

1887 Oil on canvas

For this picture, van Gogh has chosen to put his wallflowers into a pleasantly domestic still life, rather than treat them as the main subject for study. The picture has a delightfully spontaneous air, as if van Gogh has set it up on one end of the breakfast table. The light, fresh colours — creams darkening to gold in the flowers, greys and blues dashed with white in the background and the large plate and jug, pinks and light reds in the fruit darkening to a rich brown in the coffeepot — give the picture a sunny, carefree feeling.

WHEATFIELD WITH LARK

1887 Oil on canvas

The countryside around Paris provided van Gogh with fine opportunities for painting in the summer of 1887. To look at this gloriously light-drenched field of ripening wheat, filled with the fresh breezes of the countryside in summer, is to be reminded of another great art form, music. Is this a rendering in paint of what Vaughan Williams would later say musically in 'Lark Ascending'? It is not too fanciful to think so, for van Gogh was very interested in the connection between painting and music; he even took piano lessons in order to understand better what music was about.

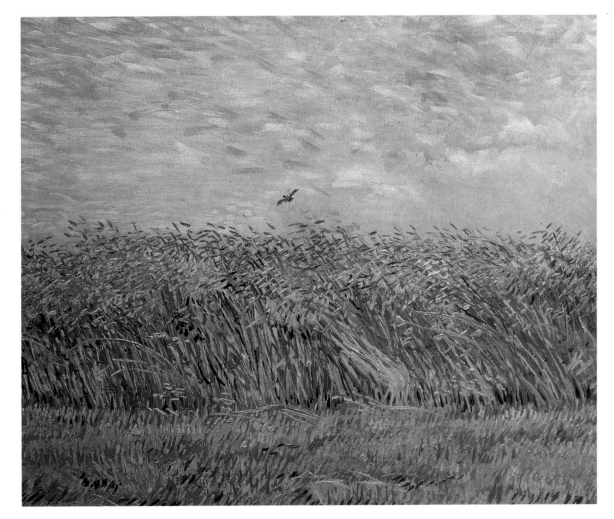

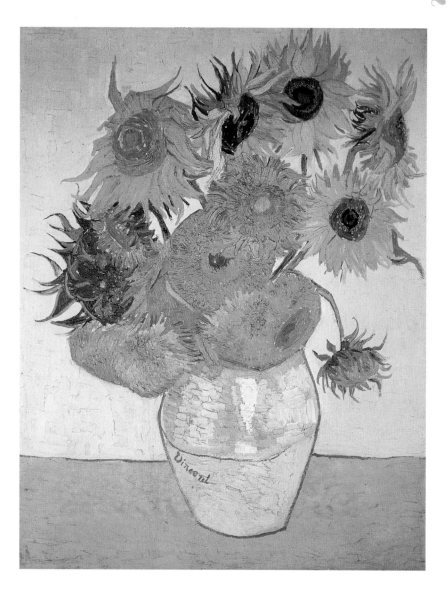

VASE OF LILACS, MARGUERITES AND ANEMONES

1887 Oil on canvas

Van Gogh has used short strokes of intense colour to lay in the background for this vivid vase full of spring flowers, reserving the typically van Gogh long sweeps of colour for the flowers themselves, especially the petals of the marguerites and anemones and the lilac leaves. About this time he was very close to the painter Paul Signac, a follower of the painter Seurat, whose theory of divisionism — using colour contrasts in small strokes of adjacent pure colours — was to lead to the style of painting called Post-Impressionism.

WOODS AND UNDERGROWTH

1887 Oil on canvas

Several Impressionist-style studies of trees and undergrowth in Paris were among van Gogh's work in the summer of 1887. In all of them, the artist's instinctive reaction to nature was clearly demonstrated. In this painting, he achieves a great feeling for the coolly shaded, sun-dappled atmosphere of a wood in summer, when everything is in a state of growth, and when there is great awareness of the vitality of nature. The canvas is not simply an exercise in using shades of green, however, for van Gogh has put in accents of red, yellow and a creamy white to give an extra dimension to the picture.

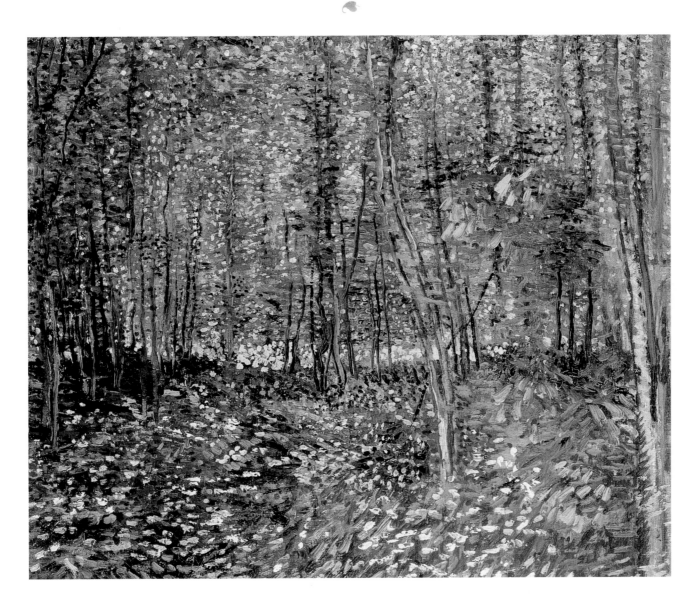

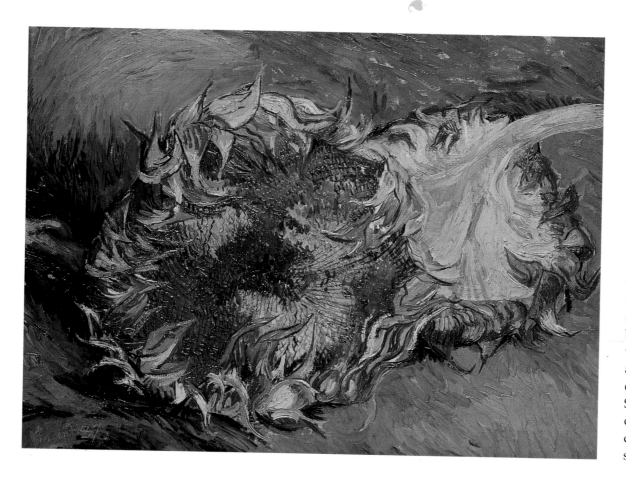

SUNFLOWERS

1887 Oil on canvas

Van Gogh made his first studies of sunflowers in the late summer of 1887, when the fields round Paris and the allotments of Montmartre were studded with their great golden heads. In each of the four sunflower studies he did at this time, van Gogh's colours were a vivid contrast of fiery, sun-filled yellows and oranges and a series of deep, rich blues. Trying to feel his own way between the contrasting, and even conflicting, theories of his friends Gauguin and Signac at this time, van Gogh chose to lay his own vivid colours on the canvases in short strokes of pure colour.

FOUR WITHERED SUNFLOWERS

1887 Oil on canvas

The sunflowers may be past their best, their petals ragged and limp, but they still make a fine subject for a powerful painting. Here, van Gogh gives us an authoritative close-up of the flowers. There is nothing delicately Impressionistic about them. It is as if van Gogh is moving towards something more powerful, giving symbolic meaning to the flowers: they may be withered but there is a great life force in them.

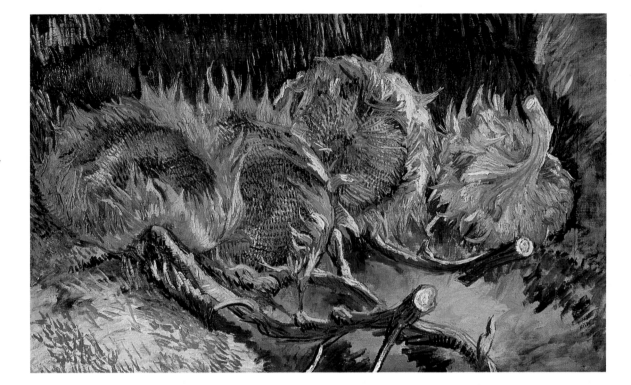

Detail

TWO CUT SUNFLOWERS

1887 Oil on canvas

The four paintings of cut sunflowers which van Gogh did in Paris in the late summer of 1887 were produced during a burst of great creative energy. Also in work at the time were landscapes, still lifes and many self-portraits. In all of them, powerful use was made of the primary colours, laid on in lines of pure colour. Having learned much in his excited discussions about painting theories with artists like Emile Bernard, Paul Gauguin and Paul Signac, van Gogh was now working towards a personal style which would come to glorious fruition in the south of France in 1888.

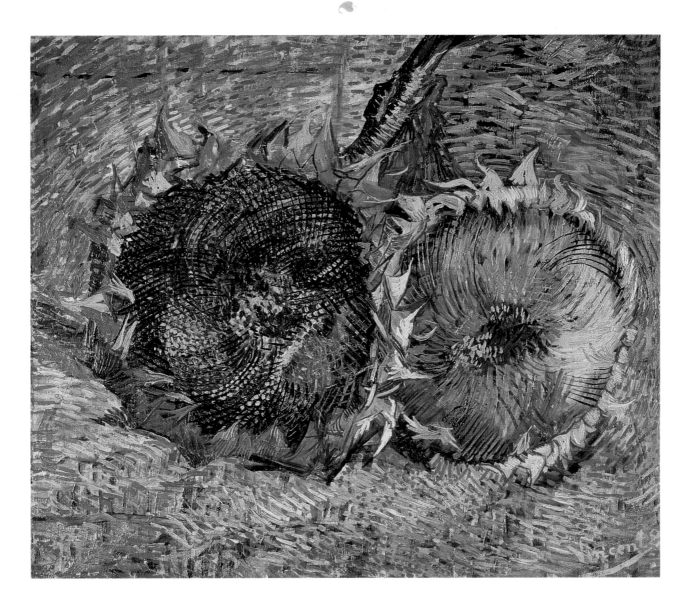

Detail

ORCHARD IN BLOSSOM

1888 Oil on canvas

When Vincent van Gogh arrived in Arles in February 1888 he stepped into a world covered in snow. When the snow melted, spring came rapidly to Provence in a glorious cloud of fruit tree blossom. Van Gogh was inspired, partly because the blossom seemed to come straight from the world of the Japanese prints he so much admired. During March and April 1888, until the blossom had dropped, van Gogh worked feverishly on a series of paintings of orchards in blossom, most of them in a distinctly Japanese style, with a flatly linear approach and with delicate colouring. This painting of plum trees in blossom was intended as part of a triptych, in which the other pictures were a pear tree and apricot trees.

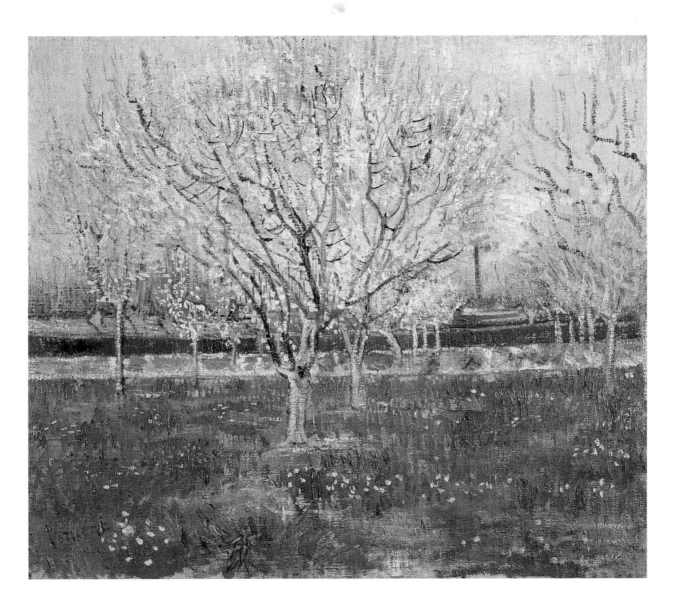

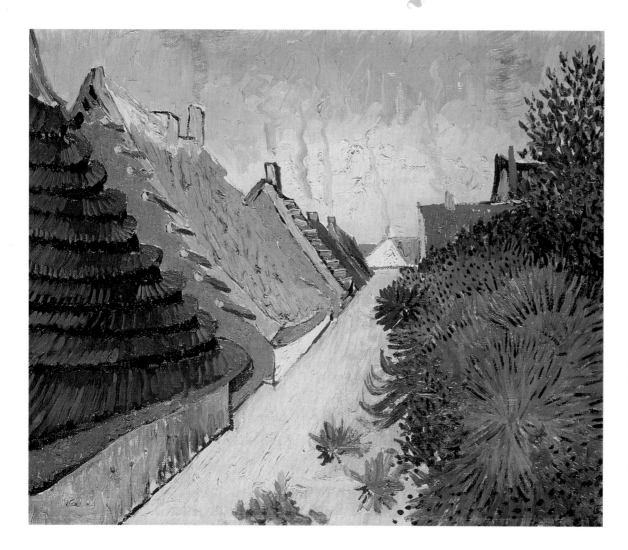

STREET IN SAINTES-MAIRIES

1888 Oil on canvas

Van Gogh's only visit to the Mediterranean while he was in the south of France was a five-day stay at Saintes-Mairies-de-la-Mer in May/June 1888. Although most of his work involved drawing and painting scenes on the sea shore, including boats drawn up on the beach and out on the ever-changing sea, he also found time to record the countryside round the small town, including the lavender fields, and the small houses in the streets of the town. This fine composition, a masterly use of contrasting complementary colours, was done in Arles from drawings Vincent made during his stay at Saintes-Mairies-de-la-Mer.

GARDEN IN BLOOM

1888 Oil on canvas

Revelling in the glorious Provence summer with its 'eternal bright sunshine', van Gogh painted this flower-filled garden in Arles from different angles at different times of day. The lack of shadows here suggests that he set up his easel for this one in the heat of the July mid-day. In describing his garden pictures to his sister Wilhelmina, van Gogh confessed that he had not drawn one flower in detail, but he believed that the impression made by his dabs of colour were all right for the painting because that was how they were in nature. An ink sketch of this painting was included in one of van Gogh's letters to his brother Theo.

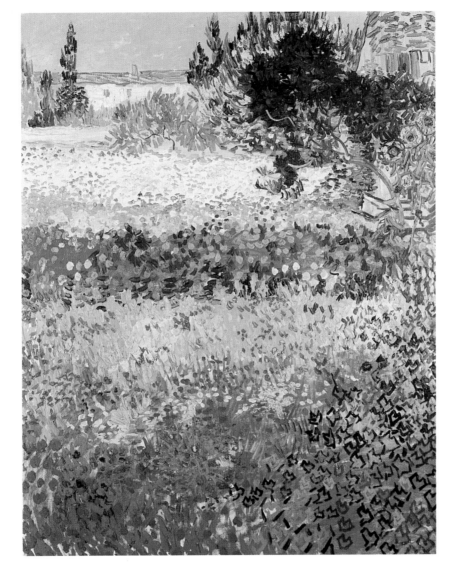

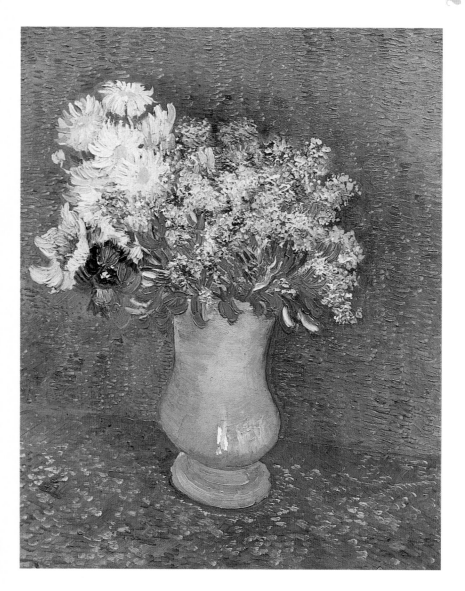

SUNFLOWERS

1888 Oil on canvas

All Vincent van Gogh's feelings for Provence are bound up in his great second series of paintings of sunflowers, the flower that, more than any other, symbolized for him the beautiful midsummer sun of the region. In mid-August 1888, van Gogh alerted Theo in Paris to his scheme for a series of sunflower pictures, to decorate his studio in Arles, in an excited letter, saying that he was 'hard at it, painting with the enthusiasm of a Marseillais eating bouillabaisse.' This painting was one of his first group of three canvases, which he intended as 'a symphony in blue and yellow'.

SUNFLOWERS

1888 Oil on canvas

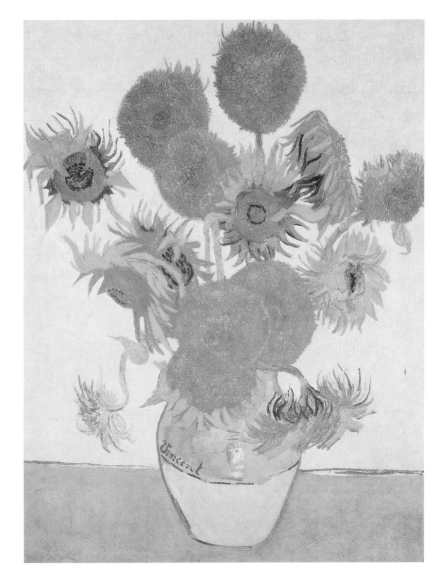

Van Gogh's original intention, in the late summer of 1888, was to paint a dozen sunflower panels. He wanted to do the whole thing 'in one rush' but had only done five paintings when the sunflower season was over. Of the five Arles sunflower paintings still in existence, two are thought to be replicas which van Gogh did in January 1889, after his first mental breakdown. This painting, a bunch of fourteen sunflowers in the same yellow vase as the one of page 36, was the fourth in the series, for which van Gogh changed his background to yellow, a colour which symbolized friendship and hope.

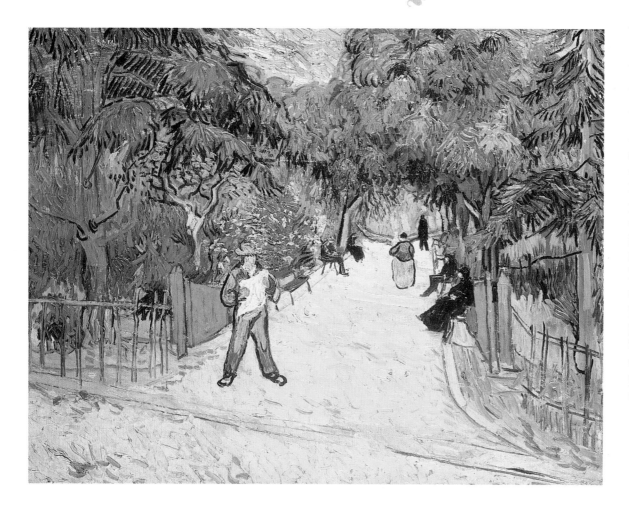

ENTRANCE TO THE PUBLIC GARDENS AT ARLES

1888 Oil on canvas

In September 1888, van Gogh moved into his own small house in Arles, the celebrated Yellow House. Near the house was a small public park which van Gogh christened the 'poets' garden', in honour of Petrarch and Boccaccio who had lived in Provence. This is one of the earliest of the several paintings van Gogh did of the park and shows the entrance to it. As in his other paintings of the park, van Gogh has painted its trees and bushes in considerable detail.

COUPLE IN THE PARK, ARLES

1888 Oil on canvas

An immense blue fir tree, spreading its branches over a bright green lawn and shading two figures of lovers walking hand in hand, dominates this study of the public park at Arles, which van Gogh had planned in drawings first (and there was a sketch for Theo, too, in one of van Gogh's many letters to his brother). Van Gogh is thought to have intended this picture for the room in which Gauguin slept when he stayed in the Yellow House in the last three months of 1888.

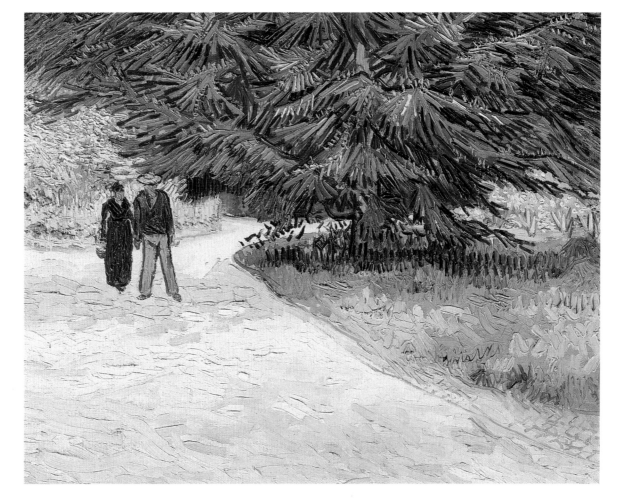

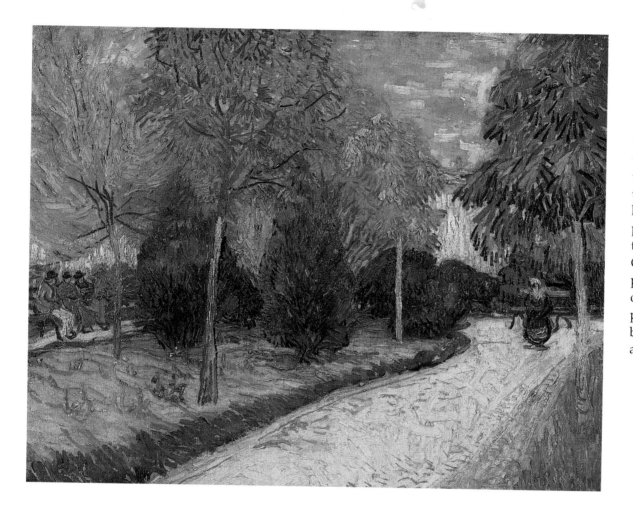

PATH IN THE PARK AT ARLES

1888 Oil on canvas

Autumn had come to Provence by the time van Gogh did this painting in the public park at Arles, so there are autumn tints among the trees' foliage. Van Gogh had planned his public park paintings for the bedroom in the Yellow House that Gauguin was to sleep in, partly because the room overlooked the park: the paintings were a way of bringing the park's pleasant atmosphere into the house.

ALLÉE DES ALYSCAMPS IN ARLES

1888 Oil on canvas

The Allée des Alyscamps was Arles' ancient burial ground, dating back to Roman times, and still had many of its old stone sarcophagi set up along its edges. Van Gogh did several studies of the Allée in the autumn of 1888, concentrating on the brilliant colours of the leaves fallen from the avenue of poplar trees which ran the length of the Allée. In this canvas the red, orange and yellow tones of the leaves are contrasted with the dark blue of the tree trunks, a colour which is carried on up through the lighter blue branches of the tree and so into the deepening blue of the sky.

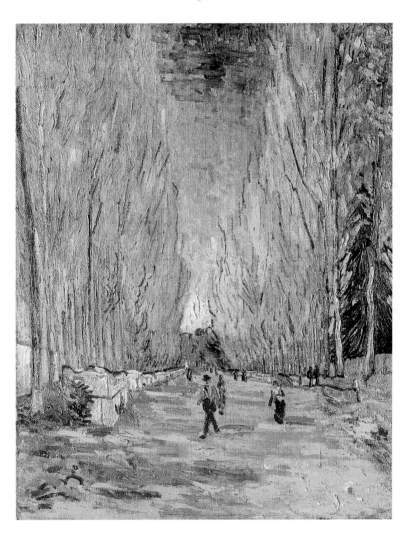

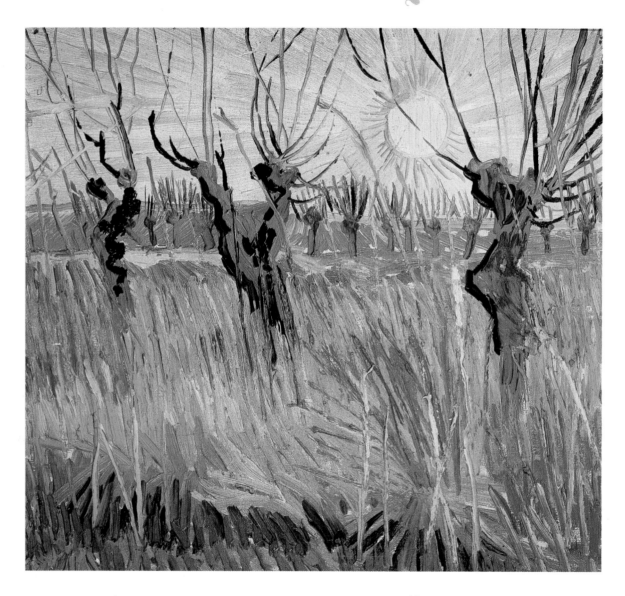

POLLARDED WILLOWS AND SETTING SUN

1888 Oil on canvas

Van Gogh painted this picture, at first glance dominated by the dark vertical lines of the three leafless willows, early in October 1888. Another look at the powerfully painted canvas brings into strong focus the sun, painted as a child might with orange 'rays' sticking out in all directions from the central yellow disc. At this time and for many months to come, the sun, rising or setting, appeared again and again in van Gogh's paintings. Like the sunflowers, the sun had become for him a symbol of life as well as a source of warmth and light.

RED VINEYARDS AT ARLES

1888 Oil on canvas

In the summer of 1888 van Gogh had filled many canvases with images of the harvest in Provence. With the coming of autumn, his attention turned to the vineyards of the region. Van Gogh painted a number of vineyard scenes in October and November, attracted by the rich colours of the grapes as they ripened on the vines. In early October, van Gogh had done a *Green Vineyard* in shades of green, purple and yellow. *Red Vineyards at Arles* was painted a month later, when the grapes were being harvested. Now, his canvas, as he described it to Theo, was 'completely purple and yellow', though he had used blue and violet for the figures of the harvesters and a yellow sun.

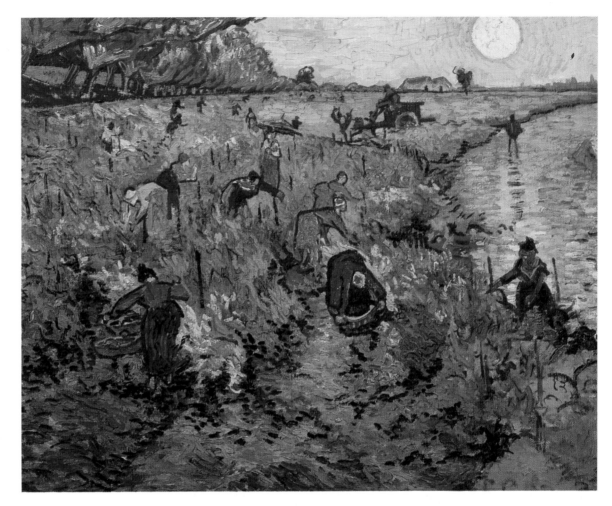

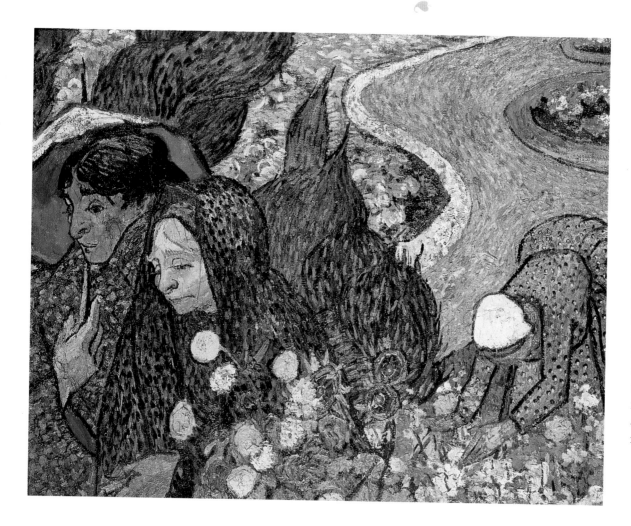

LADIES OF ARLES (MEMORIES OF THE GARDEN AT ETTEN)

1888 Oil on canvas

Van Gogh told his sister Wil that he painted this picture of women in a garden to hang in his bedroom at Arles. It would remind him of his former home and his family in Etten. The two figures on the left of the painting represented Wil, in 'a Scotch plaid with orange and green checks' and their mother, wearing a shawl the colours of which suggested her personality to him. 'I don't know whether you can understand that one may make a poem only by arranging colours,' van Gogh remarked in his letter to Wil.

LA BERCEUSE

1889 Oil on canvas

*L*a Berceuse — she who rocks the cradle — was Madame Roulin, the wife of the postman at Arles with whom van Gogh became friendly. Van Gogh did his first painting of her after he had returned to the Yellow House from his first stay in the hospital at Arles. She had just had another baby, and the string in her hand is the one which she pulled to rock the baby's cradle. Van Gogh told his brother that he wished the painting to be shown with one of his Arles sunflower paintings hanging on each side, like a triptych, because the yellow and orange tones in the woman's head would gain in brilliance because of the proximity of the yellow sunflower paintings.

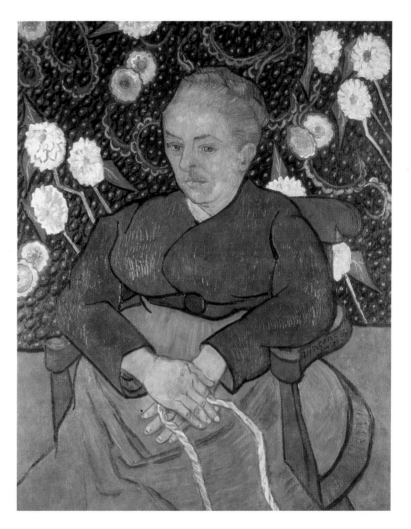

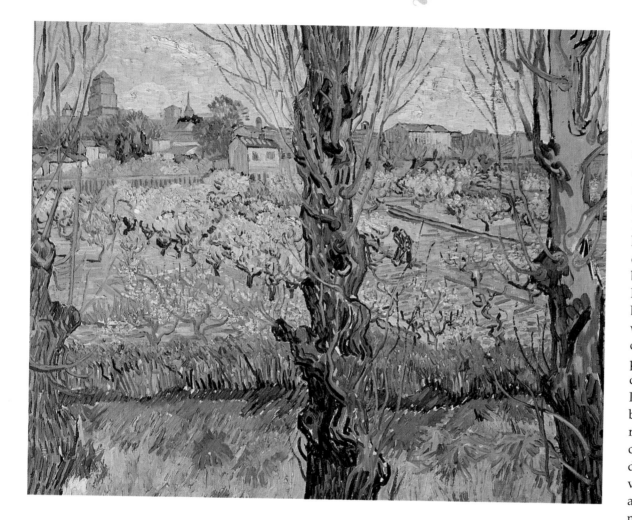

VIEW OF ARLES

1889 Oil on canvas

Also known as *Orchard in Bloom with Poplars in the Foreground,* this was one of van Gogh's last pictures of the city of Arles and surrounding countryside. At the end of 1888 and again in February/March 1889 he had had to go into the hospital at Arles, his mental condition having deteriorated badly after the departure of Paul Gauguin from the town. By the end of March he was well enough to go out into the countryside with his easel and paints. In this painting, he has depicted early spring in Provence in subtly delicate blues and violets, applied with restraint. The painting's composition is surprising: despite the domination of the verticals of the trees, our eyes are drawn past them to the man working in the orchard and to the buildings of Arles in the background.

PEACH BLOSSOM IN THE CRAU

1889 Oil on canvas

In March/April 1889 van Gogh returned to the subject of blossoming trees that had so fired his enthusiasm when he arrived in Provence in the previous spring. Painted at the same period as *View of Arles* (page 46), this picture, with its poignant echoes of those earlier fruit trees in blossom, shows that despite his illness he had lost none of his great skills as a painter or, indeed, the power to work at all, a fear which had haunted him.

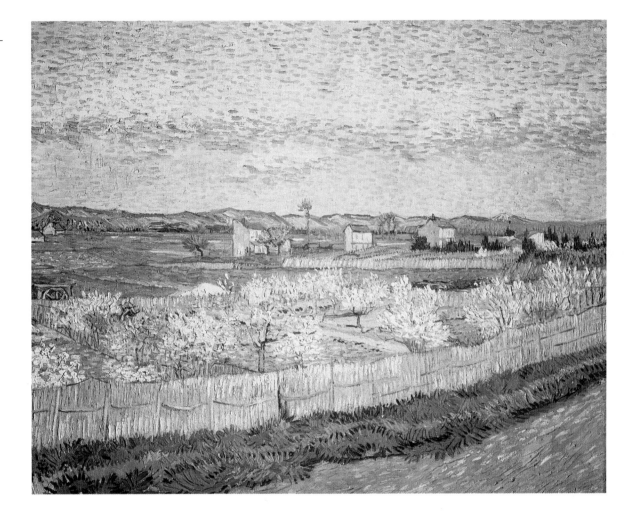

Detail

THE ASYLUM GARDEN AT ARLES

1889 Oil on canvas

The hospital at Arles, where van Gogh spent three periods between Christmas 1888 and March 1889, was housed in a handsome 16th-century building whose fine central courtyard had a well-cared-for garden. Although ill, van Gogh was able to continue painting in the hospital, and filled several canvases with intensely observed paintings of the interior of the hospital and its inmates in the wards. Van Gogh's first version of this painting of the courtyard was a detailed drawing done, like the painting, from the first floor of the building.

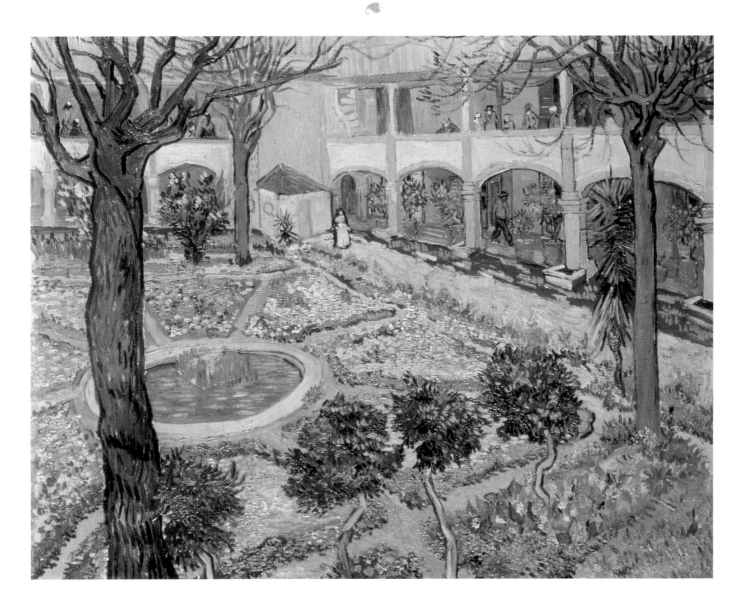

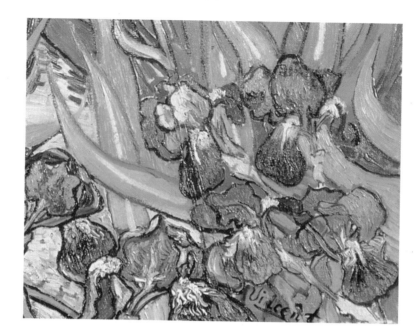

Detail

IRISES

1889 Oil on canvas

Van Gogh moved from Arles to the asylum of Saint-Paul-de-Mausole in Saint-Rémy-de-Provence early in May 1889. The asylum's unkempt but peaceful walled garden, full of flowers, proved a rich source of subjects for van Gogh. This great clump of violet irises was the first picture that van Gogh tackled, with enthusiasm and optimism, after his arrival at the asylum. Claude Monet is said to have remarked of van Gogh, after seeing *Irises* in an exhibition, 'How can someone who loves flowers and light so much, and is able to depict them so well, be so unhappy?'

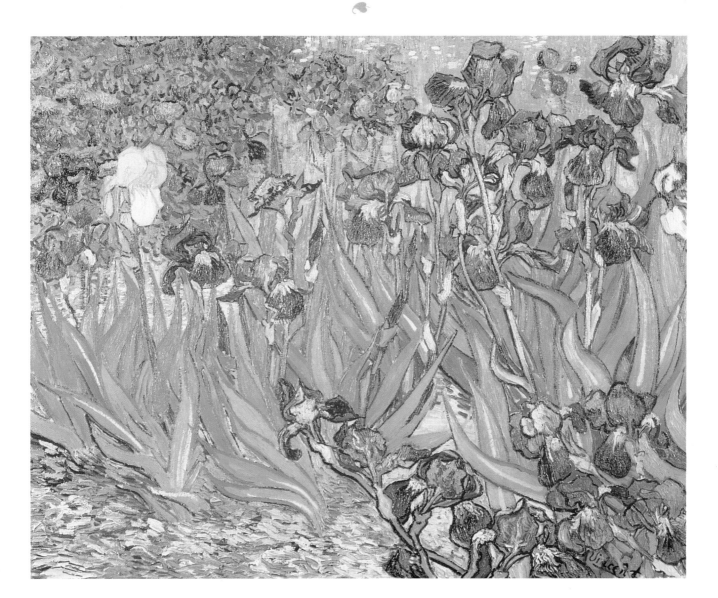

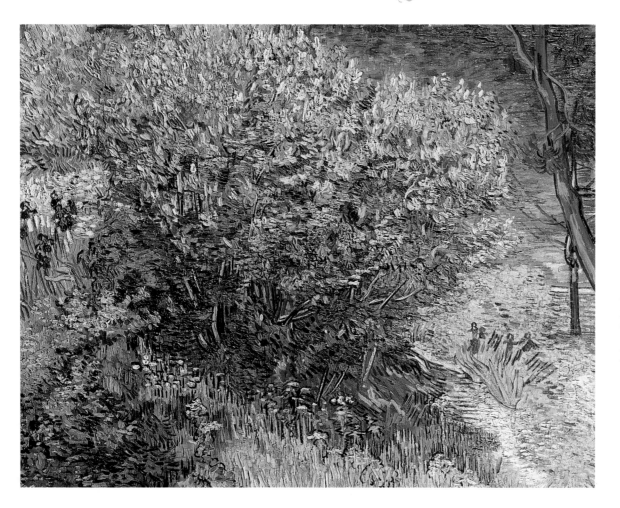

LILAC BUSH

1889 Oil on canvas

This picture of a lilac bush in the asylum garden at Saint-Rémy was begun at the same time as the picture of irises (page 51); judging by the irises in this picture, the two subjects were very close to each other in the garden. Van Gogh quickly found that the garden was an excellent place to work in; even the other patients did not trouble him because, as he reported to his sister-in-law Jo, although they would come to look at him working, they had the discretion and manners to leave him alone.

LANDSCAPE WITH GREEN CORN

1889 Oil on canvas

The combination of corn fields and cypress trees was to become among the most memorable images in van Gogh's output. Since the corn in this field is not yet ripe, we can guess that this sun-filled, serene work was painted before van Gogh returned to Arles in July to despatch to Theo paintings left in the Yellow House. The trip precipitated a mental crisis so serious that van Gogh did not paint again until the end of August. When he did pick up his brushes again, van Gogh became totally involved in depicting wheat fields, but the style had become more turbulent than earlier.

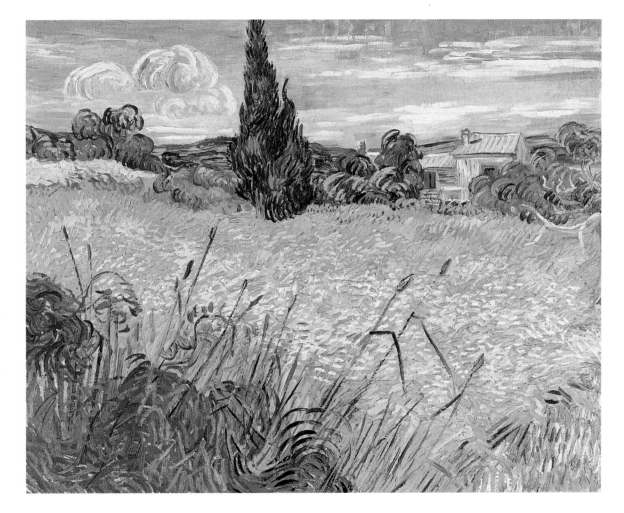

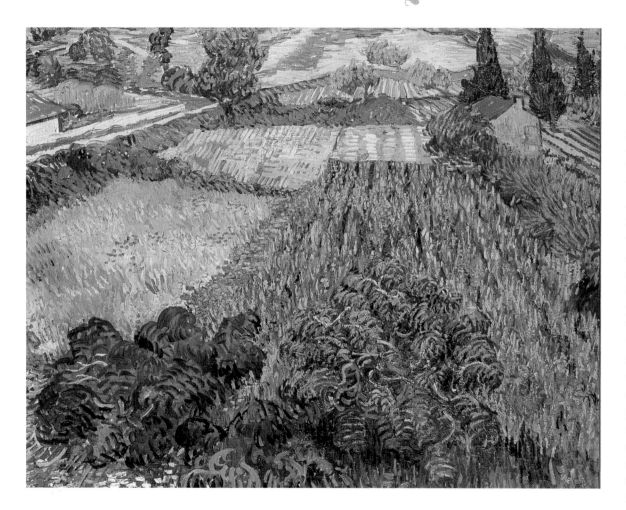

FIELD WITH POPPIES

1889 Oil on canvas

Van Gogh's early views of the countryside around Saint-Rémy-de-Provence and the hills of the Alpilles beyond were through the barred windows of the asylum. Many of his views of fields and hills of the first weeks of his time there were actually done from the asylum, though he always omitted the iron bars from the picture. Like Claude Monet, van Gogh was dazzled by the wild poppies he saw in the fields and eagerly painted them amongst the ripening corn and grasses. This painting, with its strongly drawn perspective, would seem to have been done from a vantage point above the field, perhaps from an upper floor of the asylum.

WHEATFIELD WITH CYPRESSES

1889 Oil on canvas

There are three other versions of this superb painting, including a detailed pen drawing, an oil study and a smaller replica. The subject — a field of ripe corn and cypress trees set against the jagged outline of the Alpilles — was clearly close to van Gogh's heart: he had painted it before and would do so again. This painting, in which composition, colour and brushwork are all very carefully worked out, is thought to have been completed before van Gogh's fifth, serious mental breakdown in July 1889.

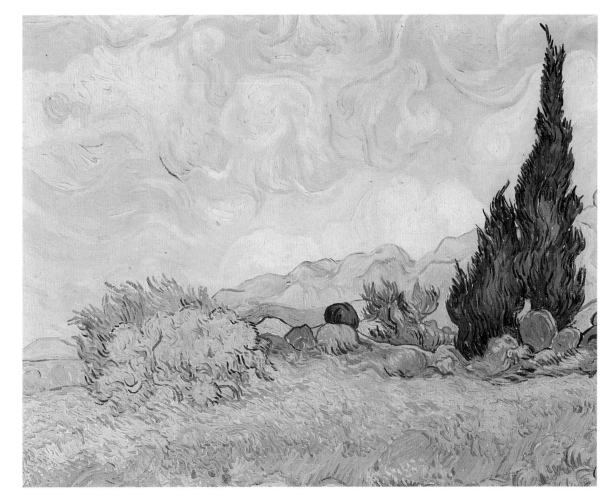

Detail

OLIVE TREES

1889 Oil on canvas

Van Gogh completed fifteen paintings of the olive groves round the asylum at Saint-Rémy in 1889. His first studies were in May / June and he had completed three canvases before the trip to Arles in July. After his recovery from his breakdown in the summer, he quickly returned to the olive grove subject, struggling to catch their extraordinary range of colours, which changed as the trees were blown by the wind, from silver to blue or a greenish bronze.

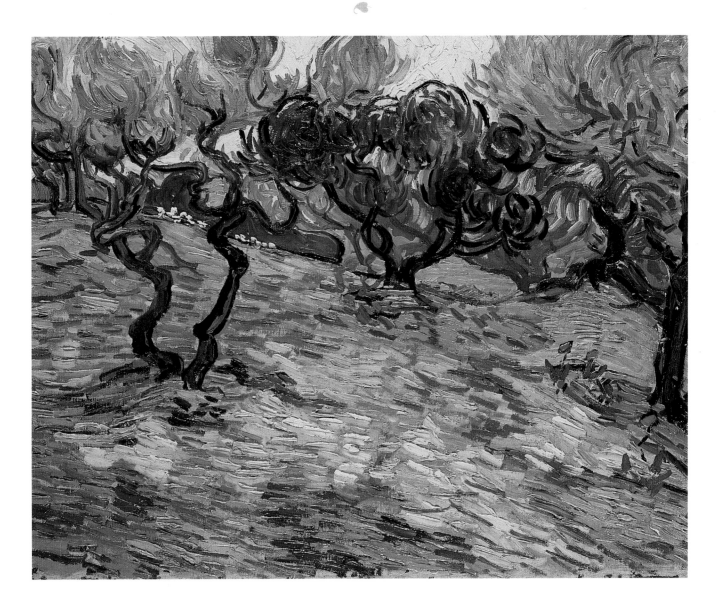

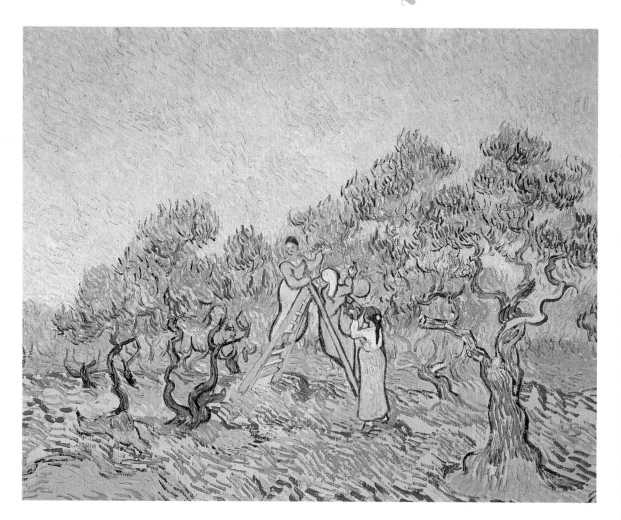

THE OLIVE GROVE

1889 Oil on canvas

Van Gogh found painting the trees in olive groves at Saint-Rémy 'very difficult, very difficult'. But the struggle to catch their true essence also suited him and drew him on. In this quiet study of the trees being harvested, van Gogh has concentrated on their grey/green colouring, though with more than a hint of the silver the trees display when being blown in the wind. One reason for working so hard in the olive groves, van Gogh told Theo, was that his other artist friends, including Bernard and Gauguin, infuriated him with their pictures of Christ in the Garden of Olives, 'where nothing is really observed'. Should he, Vincent, paint such a subject, his olive trees would be very well observed.

THE OLIVE TREES

c.1889 Pen and ink on paper

This is one of numerous detailed drawings of the olive groves at Saint-Rémy done by van Gogh, both as preliminary sketches for oil paintings and as studies of the way in which the trees grew, many of them into grotesquely twisted shapes. As he told Theo, he found the olive trees as variable as the willow trees of the North and with much the same significance for the people and the country as the willows had at home.

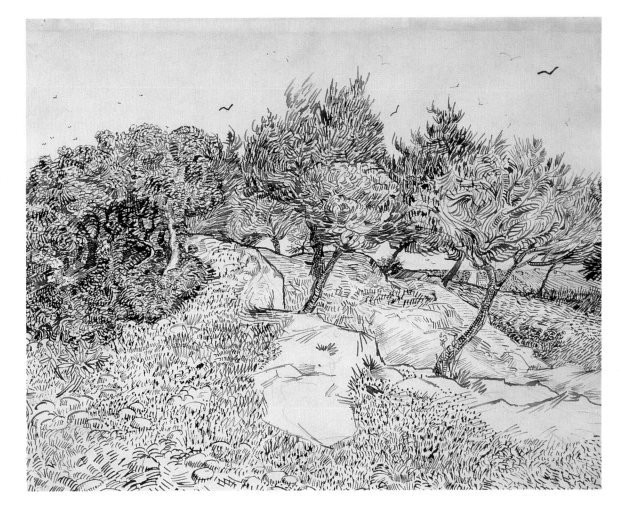

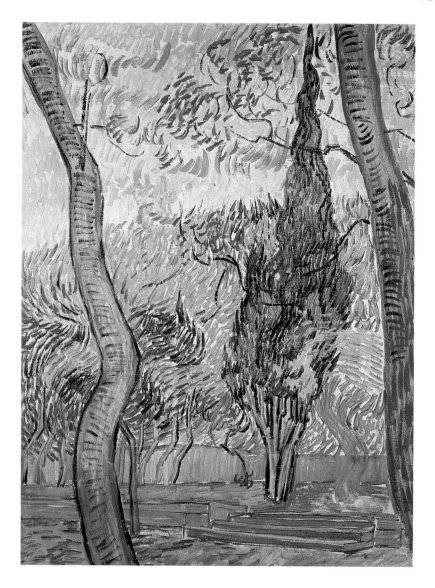

THE GARDEN OF SAINT PAUL'S HOSPITAL, SAINT-RÉMY

1889 Oil on canvas

For several weeks after his breakdown in 1889, van Gogh did not like leaving the shelter of the asylum; in the fields he would feel overwhelmed with loneliness, in the streets of Saint-Rémy he would feel a terrible lack of courage. He felt safe working at relatively undemanding subjects in his painting room in the asylum. He could see these two pine trees with a cypress between them in the garden from the window of his room.

TREES IN THE GARDEN OF SAINT PAUL'S HOSPITAL

1889 Oil on canvas

A group of tall pine trees in one corner of the asylum garden attracted van Gogh enough for him to put them into several paintings. Although van Gogh told both his mother and his brother that he shut himself into his room to paint, so that he would not be distracted, he would seem to have taken his paints out into the garden at least to start this one. He was sure that hard work was the best 'lightning conductor' for his illness.

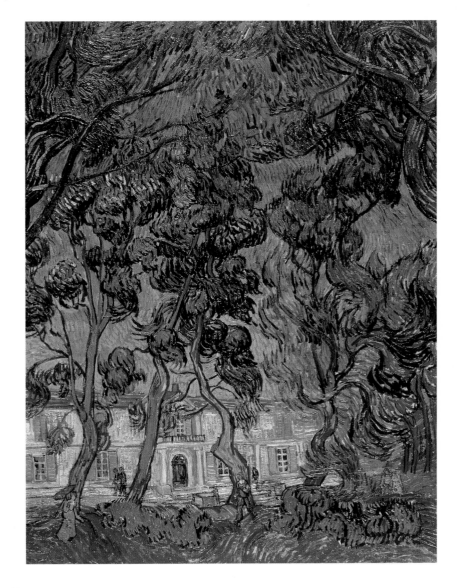

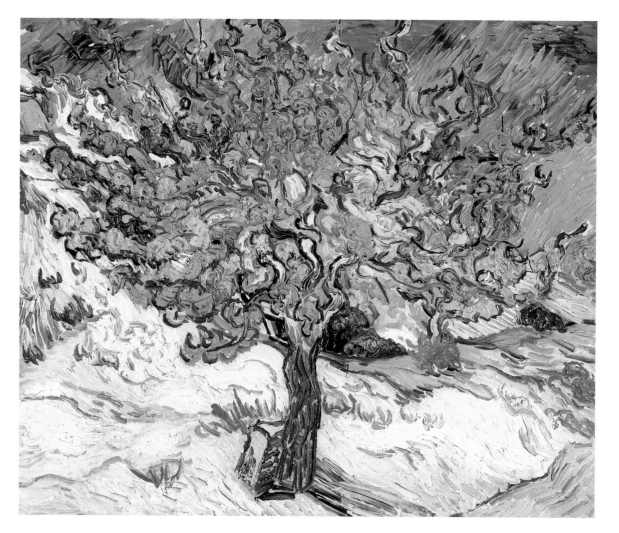

MULBERRY TREE

1889 Oil on canvas

Here is van Gogh at his vigorous best, painting a favourite subject, a tree, with thick paint quickly applied, so quickly that in places he has not covered the canvas. The colours, too, hark back to the painter before his illness, for the colours which dominate here — yellow, orange, a range of blues — are the colours he used in his sunflower paintings.

WINTER LANDSCAPE: MEMORIES OF THE NORTH

1890 Oil on canvas

By early 1890, after yet another distressing two-months-long mental breakdown during which, to his great unhappiness, he missed most of the blossom season, van Gogh was feeling very nostalgic for home and more northerly climes. He tried to assuage his feelings by painting this picture of the scenery around his family's home in Brabant as he remembered it.

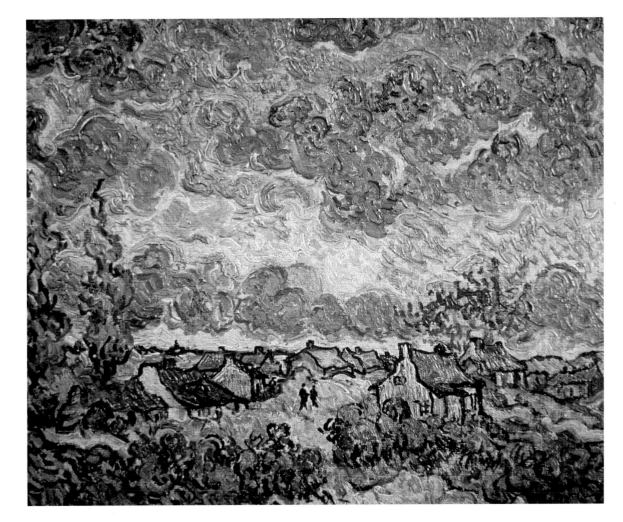

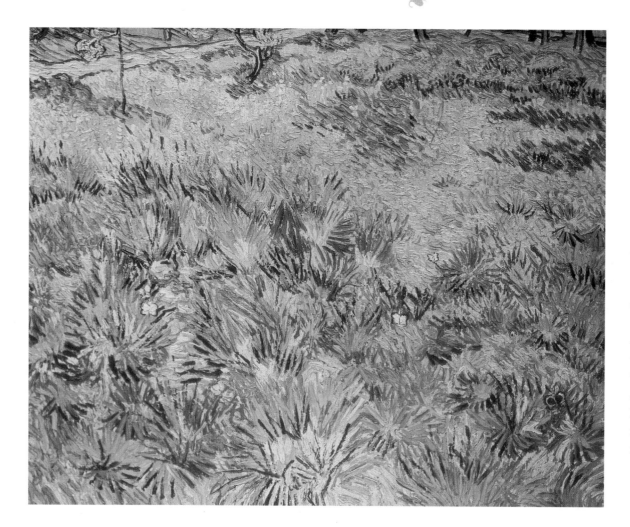

MEADOW WITH BUTTERFLIES

1890 Oil on canvas

For a time after his last and most serious mental breakdown at Saint-Rémy Van Gogh tended to keep his painter's eye down to earth, well below far horizons. There were pictures of fresh grass in the park round the asylum, where dandelions made a brave show round the tree trunks. And there were several pictures featuring butterflies. During spring, van Gogh did an oil study of two white butterflies, a painting of butterflies against a bunch of bright red poppies and this close-up of the grasses and low-growing plants in a meadow, with butterflies flitting among them.

A ROAD IN SAINT-RÉMY WITH FEMALE FIGURES

1890 Oil on canvas

Able to face life outside the asylum grounds once more, van Gogh went into Saint-Rémy in May 1890 to paint a last view of it, for he was already planning to return to the North. When he would leave, he told Theo, depended on when he finished his current canvases, on which he was working with 'such enthusiasm' that packing was more difficult for him than painting. The enthusiasm shows in this painting with its vivid colours, rapidly applied in short, strong strokes. In all parts of the painting, the canvas shows through, becoming another texture in the work.

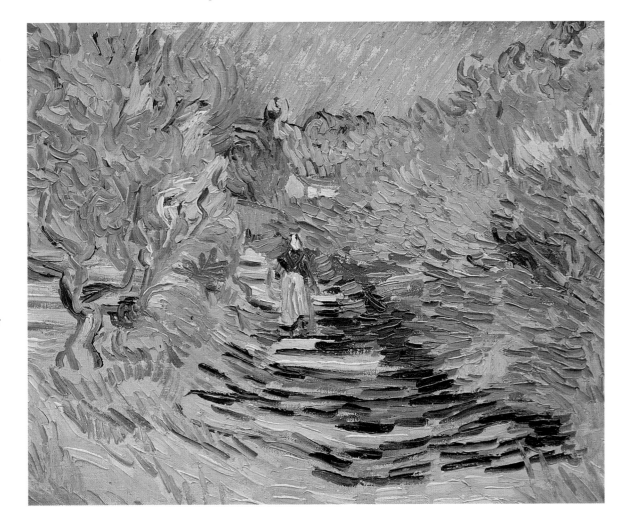

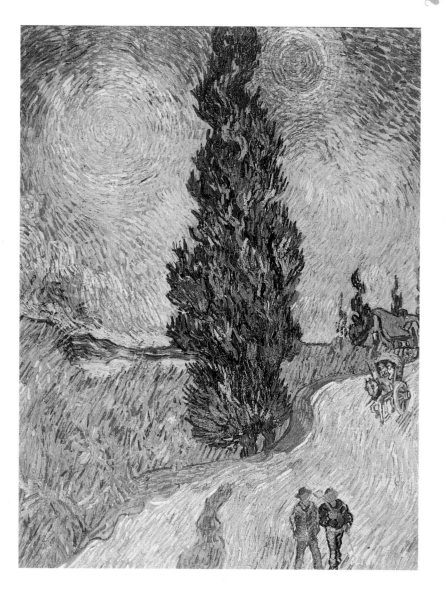

ROAD WITH CYPRESSES

1890 Oil on canvas

The last painting Vincent van Gogh did in Saint-Rémy was a very expressionistic picture, painted as much from imagination as from any reality before him. Dominating the picture is a great cypress, a tree which had occupied his thoughts increasingly over the years he was in Provence. He saw cypresses, with their shapes like Egyptian obelisks, as splashes of black in a sunny landscape.

BLOSSOMING CHESTNUT BRANCH

1890 Oil on canvas

Van Gogh celebrated the birth of Theo and Jo van Gogh's son early in February 1890 by painting a branch of almond blossom set against a blue sky, a symbol of new life. The next day he was struck down by another mental breakdown. Thus, the blossom of the south of France which had featured in his work for the past two springs, was virtually lost to him in 1890. The chestnut trees were still in blossom in the north, however, and Van Gogh was able to paint this branch of blossom from a chestnut tree shortly after his arrival in Auvers-sur-Oise.

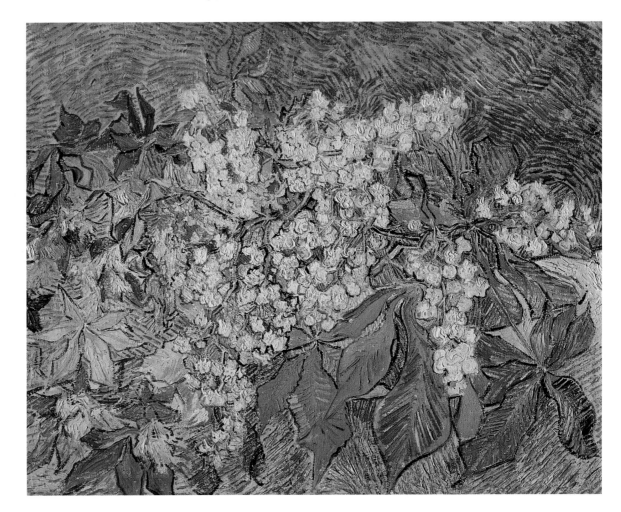

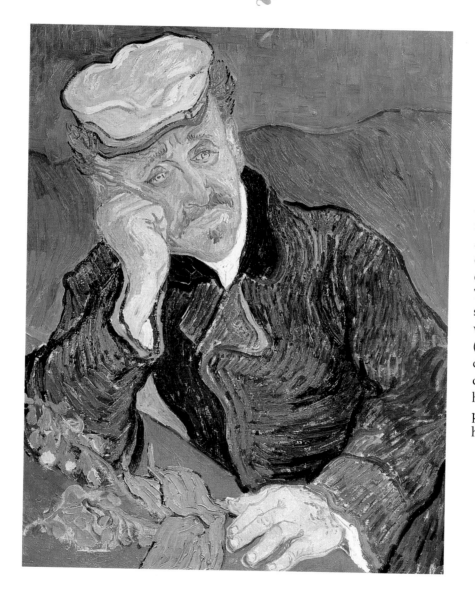

DR PAUL GACHET

1890 Oil on canvas

Camille Pissarro's suggestion that van Gogh, wishing to return to the north, could not do better than put himself under the care of Dr Paul Gachet at Auvers-sur-Oise, found favour with the artist. Once in Auvers-sur-Oise, Van Gogh quickly became close friends of Dr Gachet and his family. This superbly characterful, strongly-outlined portrait, in which the sprig of foxglove (digitalis) symbolizes the doctor's speciality, heart disease, and his interest in homeopathic medicine, was painted soon after van Gogh had arrived in Auvers.

THE GARDEN OF DOCTOR GACHET AT AUVERS-SUR-OISE

1890 Oil on canvas

Van Gogh's fifteen weeks in Auvers-sur-Oise was a time of great, even frenetic, activity during which he painted seventy oils and produced thirty drawings and watercolours. This extraordinarily energetic composition of a corner of the garden painted in shades of green, with ochre and orange highlights, was done from a high viewpoint, perhaps an upper room in Dr Gachet's house.

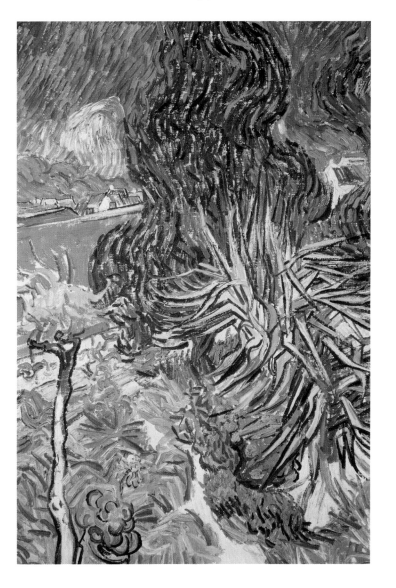

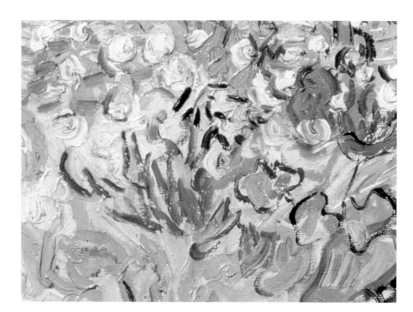

Detail

MADEMOISELLE GACHET IN HER GARDEN AT AUVERS-SUR-OISE

1890 Oil on canvas

A detail of the exuberantly painted bush of roses at the centre of van Gogh's painting of Dr Gachet's daughter in their garden at Auvers.

Van Gogh had missed the roses of the north while he was in Provence, only discovering some paintable roses at Saint-Remy in the month before he left, so he was very happy to be able to fill canvas after canvas with depictions of the richly perfumed flowers in Auvers.

Here, the gentler northern light and the lush abundance of the flowers in Dr Gachet's garden inspired van Gogh to paint some fine still lifes as well as several garden scenes like this one.

MADEMOISELLE GACHET IN HER GARDEN AT AUVERS-SUR-OISE

1890 Oil on canvas

Marguerite Gachet was Dr Paul Gachet's 19-year-old daughter, and she posed for van Gogh several times, notably for a portrait of her seated at the piano. Here, she stands in her father's garden on a quiet Sunday at the end of May, surrounded by the white roses of which van Gogh would make several oil studies in the coming weeks. For van Gogh, this painting was emphatically not a portrait of Mlle Gachet; in the painting itself and in the letter in which he described it to Theo, the artist's emphasis was on the vines and the white roses, with the white figure making a contrast in shape among them.

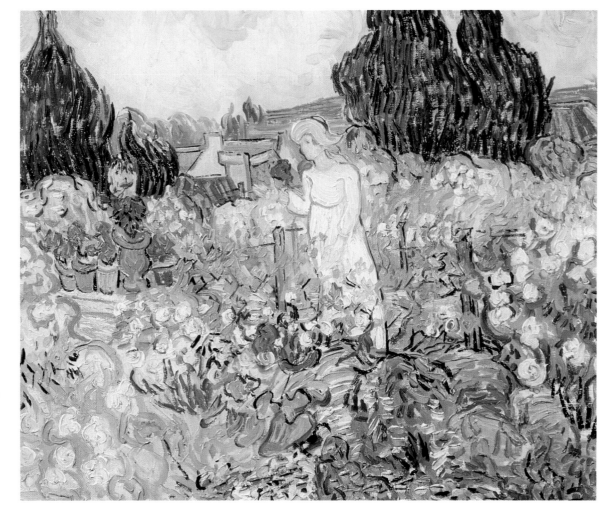

71

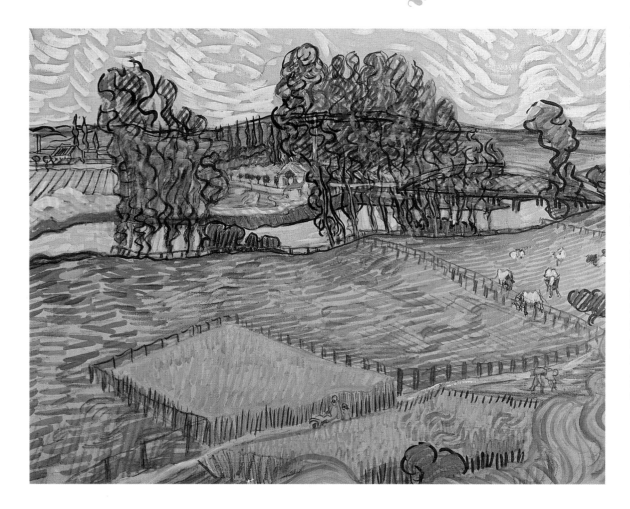

LANDSCAPE WITH BRIDGE ACROSS THE OISE

1890 Pencil, watercolour and gouache on paper

Auvers, twenty miles north of Paris, was a quiet village when van Gogh arrived there, set in the midst of a very rural community. Built in the valley of the Oise, Auvers was overlooked by a high plateau covered with a patchwork of wheatfields and grazing land. Van Gogh was inspired by the landscape into intensive activity, completing a painting a day and still finding time to do many preliminary sketches, studies and watercolours like this one.

YOUNG PEASANT GIRL IN A STRAW HAT SITTING IN FRONT OF A WHEATFIELD

1890 Oil on canvas

Van Gogh had been experimenting with doing studies of wheat, nothing but ears of wheat with green-blue stalks' as he described them to Paul Gauguin, which would be backdrops against which he could paint portraits. At first, he felt he could not draw the wheat, but soon he was seeing the variety of shades and tones in it as a visual equivalent of the rustling sound made by the ears of wheat swaying in the breeze. He was to use his wheat backdrops in two portraits of a young peasant women, one of them almost full length, and this one, in which the bright orange-red of the flowers among the wheat stalks is mirrored in her cheeks and the pattern of her dress.

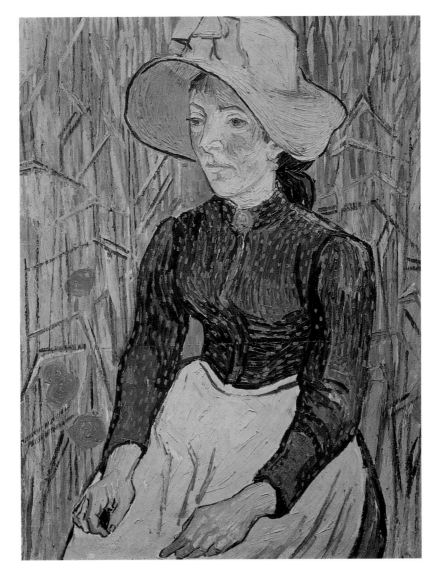

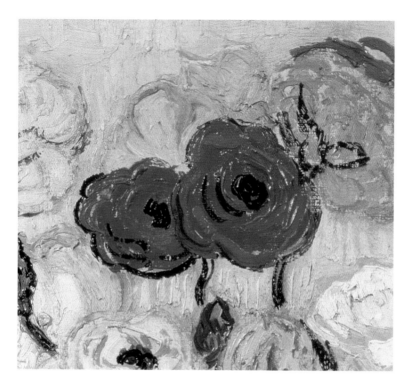

Detail

ROSES AND ANEMONES

1890 Oil on canvas

Flowers from Dr Gachet's garden and vases from his house figured in several flower studies done by van Gogh at Auvers. This bold painting, with its bright colours, strongly drawn outline and thickly applied paint, all typical of his late style, also includes some, for van Gogh, unusually sharp angling, out of its true perspective, suggestive of the still lifes of Paul Cézanne.

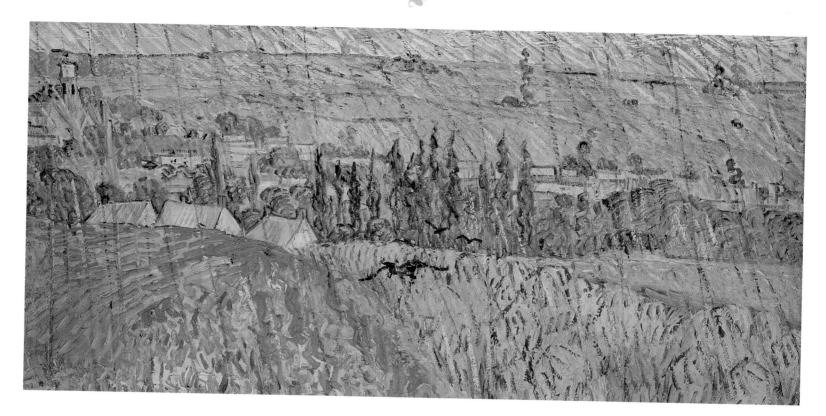

RAIN AT AUVERS

1890 Oil on canvas

Van Gogh's work in Auvers demonstrated triumphantly that his illnesses had done nothing to weaken his emotional and intellectual response to the countryside in which he found himself. This wonderfully atmospheric painting shows the village of Auvers, nestling in its valley, with the wheatfields above, stretching away to the horizon.

LANDSCAPE AT AUVERS AFTER THE RAIN

1890 Oil on canvas

This delightfully cheerful landscape, in which van Gogh has used perspective to suggest the endless fields of northern France, was painted at Auvers in June, when he was still feeling more optimistic about his future that he had for some time. He has included a worker in the fields, as well as other suggestions of the presence of people: houses, a horse and wagon and a long train, sending out an even longer plume of smoke and steam.

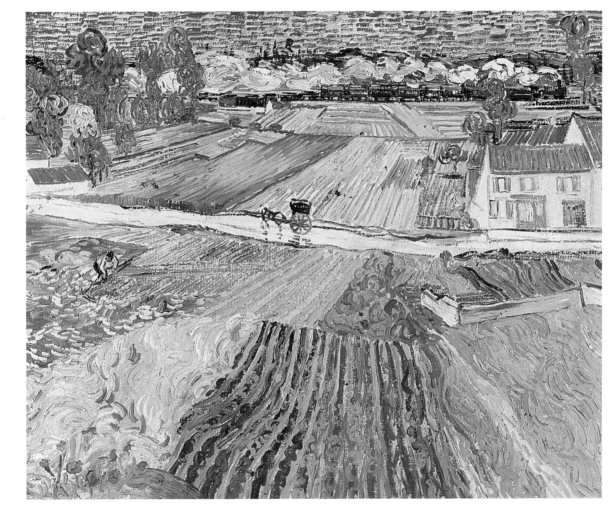

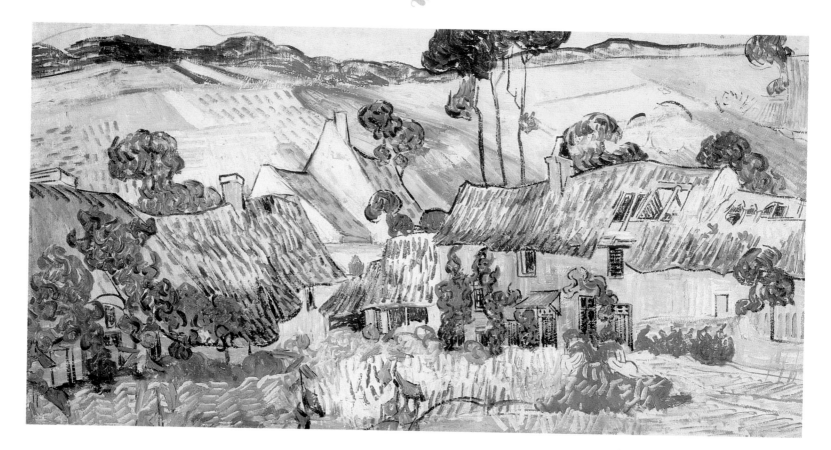

FARMS NEAR AUVERS

1890 Oil on canvas

V an Gogh was delighted to find, when he first arrived in Auvers-sur-Oise, that many of the houses retained their old thatched roofs, which were becoming rare in France, as elsewhere. He hoped that by doing some canvases of them he might be able to sell them and recover at least a part of the expenses of his stay there. The discovery of this particular group of thatched farm buildings near Auvers must have given him a great deal of pleasure.

PLAIN NEAR AUVERS WITH RAINCLOUDS

1890 Oil on canvas

Van Gogh included a sketch of this painting 'of vast fields of wheat after rain' in the last letter he sent his brother, on 24 July 1890. In an earlier letter he had also said that he was painting vast fields of wheat under troubled skies, and 'I did not need to go out of my way to try to express sadness and extreme loneliness.' Van Gogh was still optimistic about his health and the restorative forces that he saw in the country, however, and was sure that Theo would see them as well when he looked at the paintings.

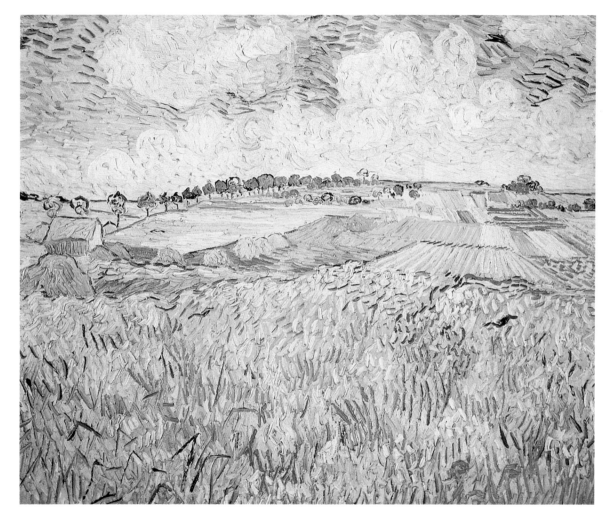

ACKNOWLEDGEMENTS

Vincent van Gogh's letters are referred to often in the text of this book. The major source in English for van Gogh's letters is *The Complete Letters of Vincent van Gogh*, published in London by Thames and Hudson, 1958.

(Figures in brackets denote page numbers.)

The Publisher would like to thank the following for their kind permission to reproduce the paintings in this book.

The Bridgeman Art Library, London, for supplying transparencies from the following collections:

Armand Hammer Foundation, USA *(15, 61)*

Buhrle Collection, Zurich *(67)*

Christie's, London *(13, 14, 34)*

Courtauld Institute Galleries, University of London *(47)*

Fogg Art Museum, Harvard University, Cambridge, Ma *(5 left)*

Giraudon/Art Institute of Chicago *(23)*

Giraudon/Heydt Museum, Wuppertal *(24)*

Giraudon/Musée des Beaux-Arts, Tournai *(59)*

Giraudon/Musée d'Orsay, Paris *(68, 71, 70-detail, 74)*

Giraudon/Museo de Arte, Sao Paulo *(16)*

Giraudon/Narodni Galerie, Prague *(53)*

Giraudon/Neue Pinakothek, Munich *(36)*

Giraudon/Private Collection, Geneva *(26, 60)*

Giraudon/Private Collection, Zurich *(35)*

Glasgow Art Gallery and Museum *(17)*

Hermitage, St Petersburg *(44, 52)*

Index/National Gallery, London *(4-detail, 5-right, 37)*

J. Paul Getty Museum, Malibu, California *(Front Cover, 51)*

Kunsthalle, Bremen *(54)*

Kunsthaus, Zurich *(18)*

Kunstmuseum, Bern *(30)*

Lauros-Giraudon/Musée d'Orsay, Paris *(69)*

Lauros-Giraudon/Neue Pinakothek, Munich *(46)*

Metropolitan Museum of Art, New York *(28)*

National Gallery of Art, Washington DC *(58)*

National Gallery of Scotland, Edinburgh *(32, 56)*

National Gallery, London *(55, 64)*

National Museum of Wales, Cardiff *(76)*

Neue Pinakothek, Munich *(79)*

Norton Simon Collection, Pasadena, Ca. *(62)*

Oskar Reinhart Collection, Winterthur, Switzerland *(49)*

Phillips Collection, Washington DC *(38)*

Private Collections *(39, 40, 45, 73)*

Pushkin Museum, Moscow *(43, 77)*

Rijksmuseum Kröller-Muller, Otterlo *(29, 41, 42, 63, 66)*

Rijksmuseum Vincent van Gogh, Amsterdam *(22, 25, 27)*

Stadtische Kunsthalle, Mannheim *(21, 20-detail)*

Tate Gallery, London *(72, 78)*